Are You in the Picture?

Kathleen Sladen

Abingdon Press
Nashville and New York

Much of the material in this book has been adapted from essays which first appeared in *Discovery* magazine, published by the United Church of Canada.

Library of Congress Cataloging in Publication Data

Sladen, Kathleen. Are you in the picture?
1. Children—Prayer-books and devotions
—English. I. Title.
BV4870.S55 242'.6'2 78-186615

ISBN 0-687-01713-0

Acknowledgments

The author and publishers are indebted to the following for the use of the pictures:

Canadian Industries Limited Collection for *Children in a Tree* by Alex Colville.

Ewing Galloway for photograph of *The Angelus* by Jean Francois Millet. Painting in the Louvre, Paris.

Philadelphia Museum of Art for *Peaceable Kingdom* by Edward Hicks (bequest of Lisa Norris Elkins '50-92-6) and *The City* by Fernand Leger (the A. E. Gallatin Collection '52-61-58). Both photographs by A. J. Wyatt, staff photographer.

Art Gallery of Ontario, Toronto, for *Study in Movement,* 1936, (purchase 1937); for *Indian Church,* c. 1930. (bequest of Charles S. Band, 1970) by Emily Carr (1871-1945); for *Reef and Rainbow,* 1927-c. 1935, (gift from the Albert H. Robson Memorial Subscription Fund, 1950) by Elizabeth Wyn Wood (1903-1966), reproduction permission courtesy of the estate of Elizabeth Wyn Wood; for *Return from School,* 1900-1903, (gift from the Reuben and Kate Leonard Canadian Fund, 1948) by James Wilson Morrice (1865-1924), reproduction permission courtesy of David R. Morrice; for *Lazarus,* 1941, by Jean-Paul Lemieux (b. 1904); and for *Barns,* c. 1926, (gift from the Reuben and Kate Leonard Canadian Fund, 1926) by A. Y. Jackson (b. 1882), reproduction permission courtesy of A. Y. Jackson.

National Gallery of Canada, Ottawa, for *A September Gale, Georgian Bay* by Arthur Lismer, used by permission of Mrs. P. N. Bridges; for *From an Upstairs Window, Winter* by L. L. Fitzgerald, used by permission of Mrs. Patricia Morrison; and for *The Orphan* by Jean-Paul Lemieux, used by permission of Jean-Paul Lemieux.

Abby Aldrich Rockefeller Folk Art Collection, Williamsburg, for *Boy with a Finch, Bountiful Board,* and *Baby in a Red Chair,* all by unknown artists.

The Phillips Collection, Washington, D.C., for *Woman in Doorway* by Charles Burchfield.

S.P.A.D.E.M. 1972 permission by French Reproductions Rights, Inc., for *The Cathedral* by Auguste Rodin.

National Gallery of Art, Washington, D.C. for *The Tragedy* by Pablo Picasso and *The Old Musician* by Édouard Manet, both in the Chester Dale Collection, and for *Christ at the Sea of Galilee* by Jacopo Tintoretto, in the Samuel H. Kress Collection.

The Trustees, the National Gallery, London for *The Nativity* (a detail) by Sandro Botticelli.

The Society for Promoting Christian Knowledge for *The Shepherds at Bethlehem* by Elsie Anna Wood.

The Prado Museum, Madrid, for *Adoration of the Magi* by Diego Velazquez.

Soprintendenza Alle Gallerie, Florence for *The Virgin Adoring the Christ Child* by Allegri da Correggio.

Mr. Henry Ernest, Montreal, Canada, for the lithograph *Mothers* by Käthe Kollwitz, from his collection.

Mr. Gordon Fox, Montreal, Canada, for the bronze *Rest in the Peace of His Hands* by Käthe Kollwitz, from his collection.

The New-York Historical Society, New York City, for *The Peale Family* by Charles Willson Peale.

The Solomon R. Guggenheim Museum, New York, for *Birthday* by Marc Chagall.

Medici Society Ltd., London, for *Loving Shepherd of Thy Sheep* by Margaret Tarrant.

Collection, the Museum of Modern Art, New York, for *Around the Fish,* 1926, by Paul Klee, oil on canvas, 18⅜ x 25⅛ (Abby Aldrich Rockefeller Fund); and for *The Starry Night,* 1889, by Vincent Van Gogh, oil on canvas, 21 x 36¼ (acquired through the Lillie P. Bliss Bequest).

Friendship Press for *At the Foot of the Cross* by Alfred D. Thomas from *Each With His Own Brush* published by Friendship Press. Photo: United Methodist Missions.

Rijksmuseum Kröller-Müller, Otterlo, Holland, for *Road with Cypresses* by Vincent Van Gogh.

Royal Museum of Fine Arts, Brussels, for *The Fall of Icarus* by Peter Brueghel.

Detroit Institute of Arts for *Frog* by John B. Flannagan, a General Membership Fund Purchase.

Stedekijk Museum, Amsterdam, Holland for *Old Shoes* by Vincent Van Gogh.

Thanks to hundreds of boys and girls

who have taught me their secret that paintings are really doors and windows. Especially I must thank Robbie, Sarah, Jimmy, Paddy, and Mary Kathleen who crowd around my desk when I'm choosing a picture. "This one! This one!" they shout. And they're always right.

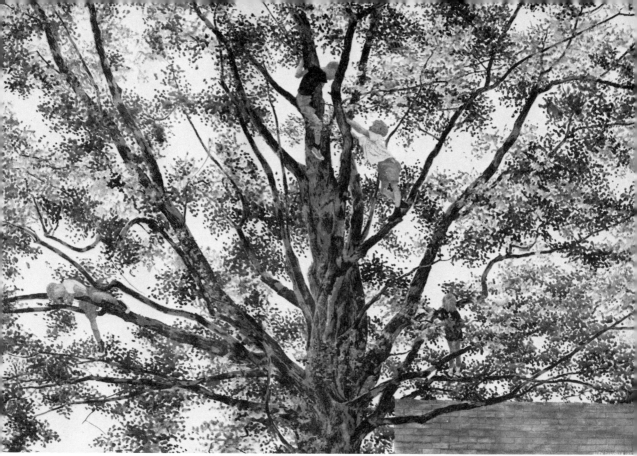

Children in a Tree by Alex Colville

Are You in the Picture?

Trees are for climbing. So you will find yourself in this picture.

Trees like this one, spread out in a comfortable network of ladders, are an invitation. Especially in the spring they keep whispering, "Come on up here with me. I have something to show you."

The boy in the black T-shirt climbed up to see if the tree was hiding a bird's nest. I think he has found it, and the boy near him can see it too. They are just looking and wondering what bird made it and how it designed such a clever nest.

The little girl below them has stopped to look at the world spread below her. Imagine how far she can see.

There is another boy in the picture. He started to climb up to see the bird's nest. Then he came to that long, straight branch, and he wanted to

crawl along it. Where he is now gives him a feeling of being held in the fingers of one of the tree's huge hands. It is a nice sandwiched-in feeling. He can lie there like a jungle boy and watch everything going on down below. He is in a tree world, and no one can see him. What is he thinking about? He doesn't look as if he were saying his prayers. But maybe he is. What would he be saying to God while the tree held him there safe and hidden from the world on the ground?

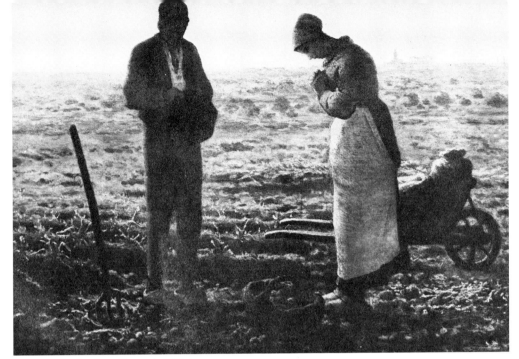

The Angelus by Jean Francois Millet

Come into This Picture

Did you ever see such a quiet picture, such stillness? A moment before, the man was working frantically, and the woman was out of breath keeping up with him!

Then the church bell rang—the Angelus bell, they called it. They stopped still where they were. The sky was still. The field lay flat in stillness. The fork, basket, and barrow were still like stone, while the people waited a moment together in the silence before God.

Our world is noisy and busy, busy. Stillness is hard to find. But we are made on a pattern that works well only if we plan to be still now and then, waiting a moment in silence before God. After this moment we are better and stronger.

At first it is dreadfully hard to be still. Sometimes a picture like this one will help. Every day for a week step softly into this picture and whisper:

1. God be in my head
and in my understanding
(*Wait a minute. Be still. Expect God to bless your mind and refresh it.*)

9

> 2. God be in my eyes
> and in my looking

(*Wait a minute. Be still. Expect God to bless your eyes and help them to be quick to see.*)

> 3. God be in my mouth
> and in my speaking

(*Wait a minute. Be still. Expect God to bless your words and speaking.*)

> 4. God be in my heart
> and in my thinking

(*Wait a minute. Be still. Expect God to bless your heart and fill it with loving thoughts.*)

At the end of a week you may not need to step into this picture any more. You will need only stillness in yourself and the words to hold you in quietness.

You will not hear the Angelus bell. But you can set a time and place for yourself, and you can meet God there.

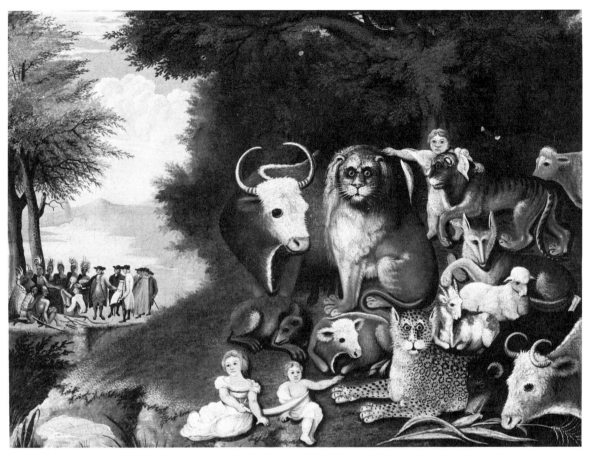

Peaceable Kingdom by Edward Hicks

Are They All in the Picture?

"The wolf also shall dwell with the lamb, and the leopard shall lie down with the kid; and the calf and the young lion and the fatling together; and a little child shall lead them.

"And the cow and the bear shall feed; their young ones shall lie down together: and the lion shall eat straw like the ox.

"And the sucking child shall play on the hole of the asp, and the weaned child shall put his hand on the cockatrice's [adder's] den" (*Isaiah 11:6, 7, 8).

11

Are all the animals you just read about included in the picture on page 11? The asp and the adders are not to be seen, but look at the right hand of the small child at the front of the picture. It is stretched across the opening of the asp's hiding place.

The left hand of the girl beside the young child covers a similar opening. Neither of the children seems to be the least bit afraid of the poisonous vipers. Animals, children, and grown-ups in the painting are happy and friendly and unafraid. No wonder the artist called his picture, *The Peaceable Kingdom.*

Television, newspapers and magazines tell us every day about people who are afraid, who are fighting or threatening to fight each other. There are strikes. There is picketing. There is cruelty between people of different colors. There are fights in the school yard and in the backyard. There are quarrels in the house.

God doesn't want any of this. He wants us to be happy and to enjoy everything he made. If everybody really wanted it enough, the world could be a peaceable kingdom.

We believe that someday what God has said about a happy world will come true. His kingdom will come.

Whenever we pray the Lord's Prayer, we ask for this—"Thy kingdom come."

Look at this picture often. When you say the Lord's Prayer, see this picture in your mind and say to yourself, "That's what it can be."

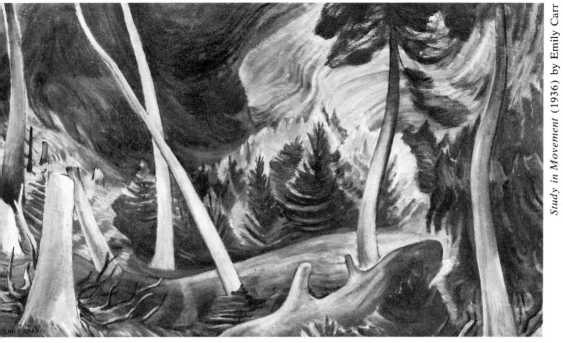

Study in Movement (1936) by Emily Carr

Can You Keep up with This Picture?

Almost everything is moving! Is it like a dance? Or is it like the movement of music?

The tree trunks, in all the exciting aliveness, cannot stand stiff and straight. They are caught into the music, too.

Some of the great evergreens wave like banners and others are dancing like dark flames of fire.

The little spruce and fir trees in the center are whirling and spinning like tops. They have tangled the sunshine in their circle. Now it, too, must dance 'round and 'round.

Right in the center there is something like the rousing volume of a full orchestra. Even the clouds have dropped down and are moving softly in to join the chorus.

Trees don't sing and dance the way we do; but the artist feels that the forest is not still, or wooden, or without joy and feeling.

Can you keep up with the exciting chorus of the trees?

Do you feel drawn into this wonderful expression of joy—the joy of being alive?

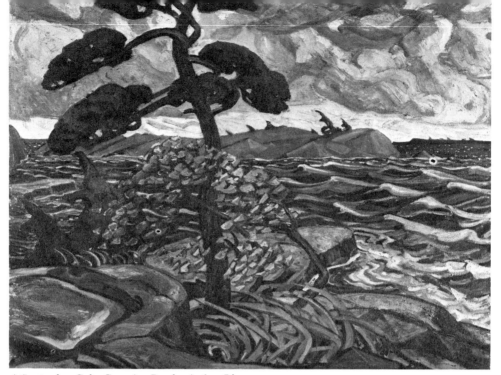

A September Gale, Georgian Bay by Arthur Lismer

Have You Felt like This Picture?

Suddenly—

Just when things at school, on the team, and at home are just fine, everything changes.

Just like this picture—only a few minutes ago the sky was blue. The bay was a big, quiet pond. The rocks were warm and friendly. The pines stood still, and the shrubs and tall grasses were asleep in the sunshine.

That was a few minutes ago. Look at the gale we have now. Nothing looks the same or feels the same. What was friendly and safe has turned into something hostile and threatening. The clouds are weird. Wave after wave is leveled at the islands on every side. Threshing trees, shrubs, and grasses are angry, resisting. The artist called this picture *September Gale*.

When everything around us suddenly changes as though a gale has struck us, this picture can help.

It says that gales do come, that they do change things. But, after all, they are not tornadoes—only September gales.

We see things and learn things in a gale—things that all the calm summer days will never show us or tell us. The islands, the bay, the sky are God's. He built strength into them and into us. This is stronger and truer than the strength of the passing gale.

Is This a Picture of You?

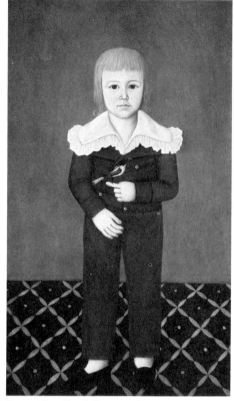

Boy with a Finch by an unknown artist

No, it's not you. It's someone much younger wearing old-fashioned clothes. Is he real, or is he a dummy?

He's real, all right. It's just that he is having his portrait painted. And that's a serious business.

His mother has pressed his suit with great care. What a funny collar she put on it!

The bird was not her idea. The boy thought of that. The grownups seem to have said, "All right, but stand still and look straight ahead. Remember, if that bird starts flying around, back he goes to his cage, and no nonsense."

This must have made things exciting.

You can see the bird doesn't intend to play this game very long. The little boy knows it, too, by the way its feet feel on his finger. He mustn't look down, but he is all ready to catch it when it flies. And it's going to, any minute now! The boy will run after the bird, knock over the painter's easel, spill the oil paints on the parlor carpet, upset the bird cage, trip the artist by mistake—and run smack into his mother in the doorway.

Just now he is standing, looking at you, looking like all younger boys and girls do—just a bit lonely sometimes, not saying anything, just thinking how much they'd like to be friends with you who are older.

Do you know any little boys or girls around this age who want to be friends with you? Do you let them tell you things sometimes? It doesn't take long, and they feel just the way you felt when you were five or six years old. Remember?

15

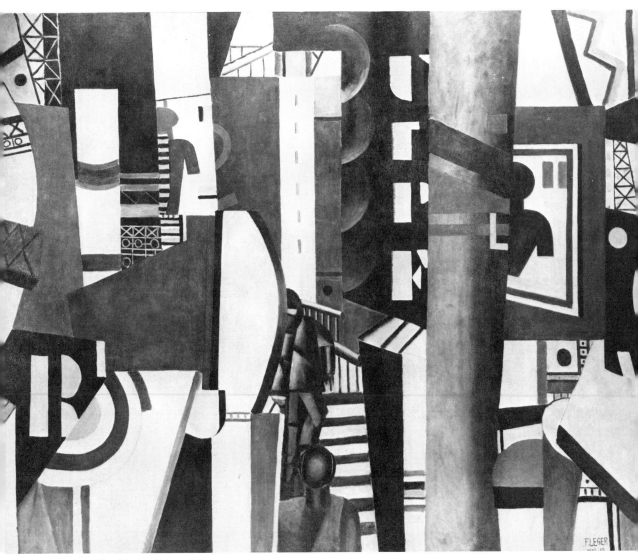

The City by Fernand Leger

Have You Ever Been in This City?

If you visit in any modern city or if you live in one, you will recognize this picture.

In a way, all modern cities are alike. All of them are in a hurry. All of them are growing. Everyone in them seems to be involved in getting something built, rebuilt, moved, torn up, or planned.

The noise of all these activities—the working of huge machines and cranes, the climbing of scaffolding, the roundabout of detours—competes with the sounds of business, of buying and selling, of going and coming, and with the glare of lights and billboards.

The volume and tempo of all this, of endless hurry in all directions, stirs up a feeling of excitement. If you walk or drive slowly, you are in people's way. They will be annoyed because you are holding up the traffic. There is a feeling of nameless adventure. You are part of it and must push on with haste.

Look at the artist's way of painting the city. Do you see the building operations, the buying and selling, the factories and storehouses, the sky-scrapers and the underground excavation? Can you sense the strong colors indicated and the contrast in shapes? Can you feel all of them clamoring up together, so that there is no space left open, no air or sky? There is nothing here on the surface but man's work, man's building and planning and striving.

Your eye is not allowed to stop anywhere in this painting. It must keep moving. Like the city, it must not rest.

There is no really human shape in this picture—just machine men in a machine world. But there is excitement, and there is a kind of beauty in pattern and contrast and achievement.

What if there were no real men in this city? What if nobody cared that there were no real men or women or children in this city?

Can Your Hands Make This?

The sculptor Rodin carved these hands and called them *The Cathedral*.

He believed that what people feel is written on their faces, and also that every muscle of the body shows the happiness, despair, or hope we feel inside. He felt that hands, in particular, tell the story of our thoughts and feelings.

He was very interested in cathedrals, the large churches built by architects (artists like himself) who sang their praise to God in stone, wood, and glass. These men hoped that when people entered their cathedrals this kind of music would lift their hearts in praise to God. When this happened, the people, the place where they stood, and the very air they breathed would become a glorious hymn. It would be a moment when everything combined completely and only for worship. Love and obedience would be offered to God, who is all in all.

Do you suppose that hands always reminded Rodin of the cathedrals he knew and loved?

Most of us, when we were very young, used to say, "Here is the church. Here is the steeple. Open the door and see all the people." Our hands reminded us of church.

Did you discover that your hands would not make this picture?

It takes two people to make this cathedral. It takes two right hands!

Do you suppose Rodin called his sculpture *The Cathedral* and used hands that belonged to more than one person because he wanted us to think about coming together with other people to worship?

The Cathedral by Auguste Rodin

20

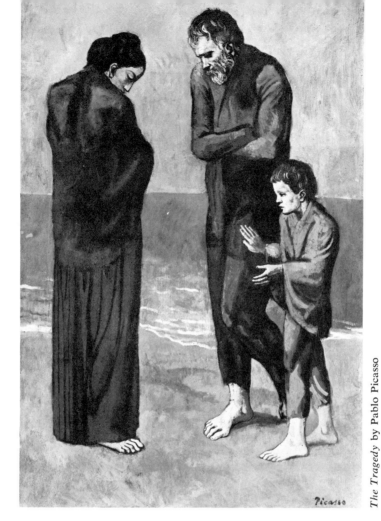

The Tragedy by Pablo Picasso

What Has Happened in This Picture?

The artist says it is a tragedy. Something very sad has happened in the lives of these people. Even the surroundings show this. The joy and beauty of sky, sea, and land have drained out, leaving only a gray, chilling air about the three people who stand before us.

We can only guess what the trouble is. Has there been a dreadful quarrel between the man and woman? They stand close to each other, but they feel far apart. The woman is hurt. The man is sad.

Look at the boy. He is frightened by this quarrel and very sad. He loves them both and wants them both. His hands will tell you that. One hand so lovingly and gently speaks to his father. His other hand is calling

21

without a voice to his mother. There is nothing he knows how to say, but all he feels can be seen in his face.

The hands of the man and the woman are not held out. They are drawn in and hidden. You can see by the lines of their bodies that they are drawing away from each other and into themselves. They have a frozen kind of look.

The boy's hand, where it touches his father, seems to soften the man a little.

Boys and girls sometimes see grown-ups quarreling. It is never a pretty sight. It is sometimes frightening, and they wonder what to do or say. They wish this had not happened. They wish they could help.

The boy in this picture is doing the best he can.

Perhaps tomorrow will be different. The sun will shine, the waves dance, and the man and woman will reach out their hands, and then all three will throw their arms around one another.

Perhaps the quarrel will go on. We can only guess about people.

We don't have to guess about God, though. He will be with them, loving and caring. He will be able to help if they want Him to. He will not leave them whatever happens. Whatever they do, He will not change in His love for them.

What a difference this can make to the boy. I hope he knows about God, don't you?

Can You Feel This with Your Eyes?

This is a hard-and-soft picture (not of a painting, but of a sculpture in metal).

Here is the softest thing you can imagine—a rainbow—against one of the hardest things you might think of choosing, a jagged piece of rock— a reef.

This sometimes frightening kind of rock lies close to a shore and is partly, or altogether, hidden by water. When you are cruising around or when you want to bring your boat in to a landing, you have to watch out for hidden reefs that could rip the bottom out of your boat.

Why do you suppose the sculptor put together two such different things? Well, both of them are real. Most of us have seen rainbows; some of us have had experiences with jagged reefs, either when we have been swimming or when we have been out in a boat. Would we put these two real things together to tell a story, and if we did, what story would they tell?

Did you notice that the reef is not as jagged as it once was? Its very sharp and jutting angles have become softer. As you look at it your eye feels a smoothness that it transfers to your fingertips, telling them how to imagine the almost rhythmical flow of the gentle ridges, moving back and forth like the soothing feeling of a quiet song. When your fingertips transfer this to your ears, they pick it up as wave music washing endlessly against the reef.

It has taken a long time for this jagged thing to become so changed. Once it was frightening like a scream. Now it is almost a song caught in stillness.

And the rainbow. It is more solid here than the ones we see as lovely scarves of color in the sky. Rainbows do disappear, but have you ever thought about how many thousands of them appear? The sculptor says this with her strong arc of rainbow.

This sculpture may not talk to you about anything more than its beauty. But if you were once very sad or hurt or ill, it may say to you, "Look, even the jagged, hurting things are not so bad after a while. They can be made into a kind of song. And always, always there is another rainbow."

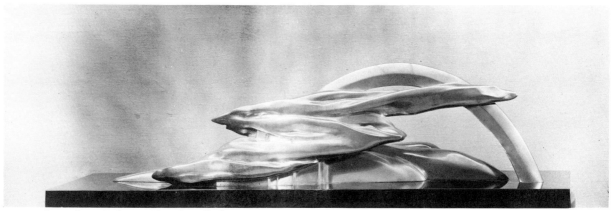

Reef and Rainbow (1927-c. 1935) by Elizabeth Wyn Wood

How Would You Like to Get into This Picture?

Everything about this picture seems to say, "Come on in. Help yourself. It's all for you."

Do you think it could be a Thanksgiving table? And how do you suppose all these things happened to be put together in just this way?

The autumn fruits must have been picked over and the best ones chosen. The nice drop-leaf table was the right size, but where should it be placed?

The choice turned out to be right in front of the very new drapes, rich with their fringe and tassels. Their color would set off the fruit and make a kind of frame around it.

Next came the choice of an interesting table cloth. But the arrangement of the fruit was the most important of all.

The slice cut from the great, dark green melon got the center of the stage. There it displays all its secret of sweetness. It is a brilliant pink, dotted with shiny dark seeds. The juice is bursting through to trickle down your chin.

There is another sweet melon close by and peaches, bananas, and grapes galore. A cut lemon is handy in case you happen to like that with your melon. There are bowls of sugar, too, with spoons that reach for your hand.

Somebody must have said, "Isn't that a picture?" Perhaps after that was said, someone ran to get the flowering plant.

But that made the rest of the wall behind the table look a bit plain. Somebody thought of Cousin Sally's nicely framed picture. They hung it right in the center.

Can't you feel how pleased they were? Everything was full of welcome and warm happiness.

It is a lovely, homey combination of three good things—God's gifts, man's work, and the joy of putting these two together.

Try to decide where each one of the twenty things in this picture belongs. Which are God's gifts? Which are man's work? And which ones show the joy of putting the two together, to share them with somebody else?

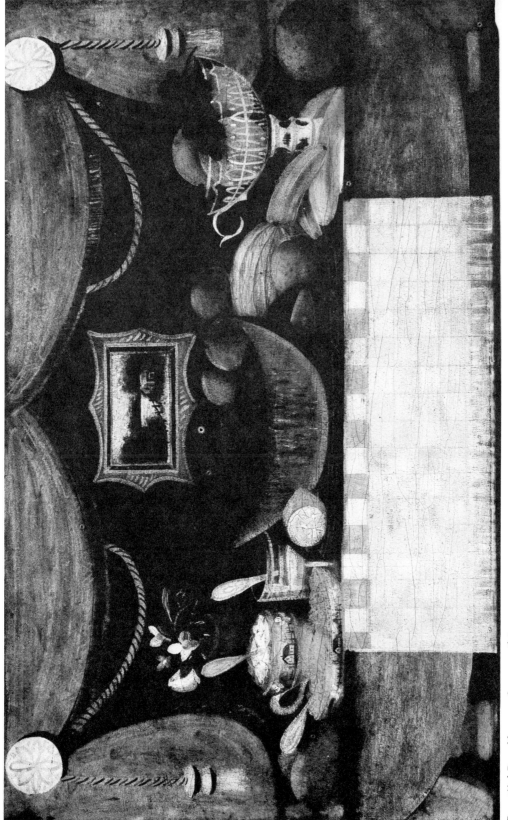

Bountiful Board by an unknown artist

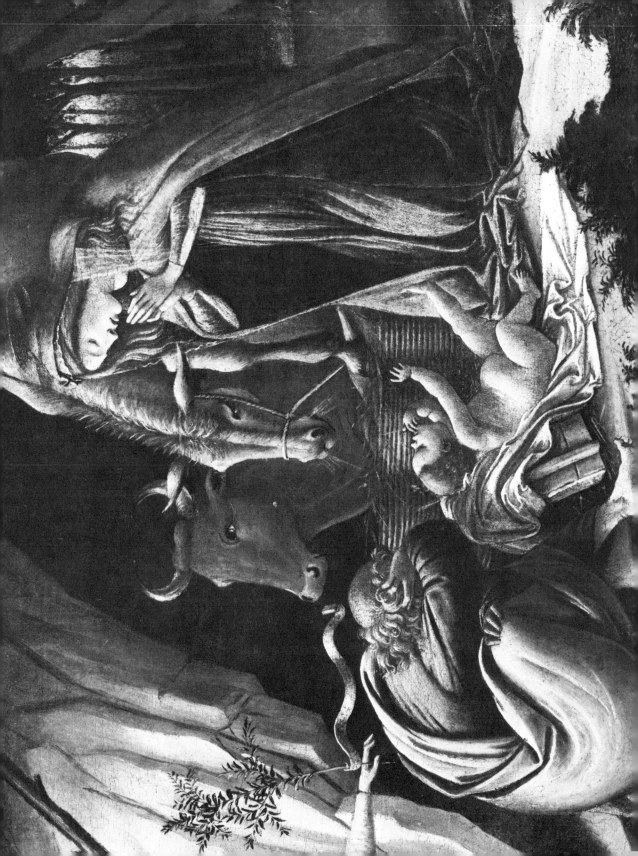

Can You Hear This Picture?

You may not hear it at first. But if you will look around the picture, something may happen.

There is the Baby in the center. We must come back to Him again. Away over to the left is an angel's hand holding a branch from an olive tree, a sign of peace. What looks like a ribbon of paper or parchment floats out from the branch. Is it the music and the words of the angel's song, "Peace on earth, good will toward men"?

The cow has a look of keen awareness and aliveness. Does it feel the presence of the angel? The donkey only cares that the Baby is there. He has forgotten that his mouth is full of hay. He feels pulled toward the Baby by a kind of longing that is stronger than hunger.

Mary knows that this Baby is like no other baby. He is the Son of God. She is worshiping Him. She seems to be without words, and yet her whole body seems to speak.

When you first look at Joseph, he appears to be asleep, but his hands and feet tell you he is very wide awake. He is drawn to the Christ Child so strongly that he is almost overcome with feeling. He has never felt like this before—so full of wonder and amazement.

And now back to the Baby. He feels the love and worship around Him and is reaching out to answer it. No artist has been able to paint the Christ Child so that all God's love is shown. All we can do is to be still and re-member this.

You have been around the picture. Can you hear anything? Not really, perhaps. But the angel, the animals, Mary and Joseph, all together, seem to make a kind of hymn without words around the Baby.

Did you notice the lightness of the angel's hand, like music, and the singing kind of lines in the drawing of Mary? The lines that make the figure of Joseph go round and round like the lines of a chorus repeating itself over and over trying to reach beyond its words. The animals are made more beautiful than they really are because they are part of the music of the first Christmas.

Look at the picture again. Do you feel that while your eyes see this picture you have another sense, a sense, somehow, of hearing it, too?

The Nativity (a detail) by Sandro Botticelli

27

Are You in This Picture?

Look at it this way. This picture is a window. You are standing, so quietly that no one guesses you are there, looking in, seeing everything going on.

Seven pairs of eyes are looking at the Christ Child. No one is speaking. They feel as if they haven't any words. This is because they know that this is not an ordinary baby.

What do you suppose the first shepherd is thinking?

The second shepherd is thinking in his heart. Can you find words for him?

The third one is not the same age as the others. Can you guess his thoughts?

Joseph never was much for talking. But he has thought a great deal about who this Baby is.

Mary—what is in her face?

And the lamb—does it know something? Does it feel something from the people around it?

The boy—we can't see his face, but the round of his cheek lets us know he is smiling.

Beside the window where you are standing is a door.

Step in, silently, and stand beside the boy.

Now there are eight pairs of eyes looking at the Christ Child.

What are the wonderful thoughts you have in your heart when you look at Him?

Yes, it is only a picture. But it is a picture of a true story. The Christ Child did come. Shepherds did come to see Him. You have come to see Him, too, all the way to long ago in Bethlehem. You have come because Christ belongs to now, as well as to then.

You are in the picture.

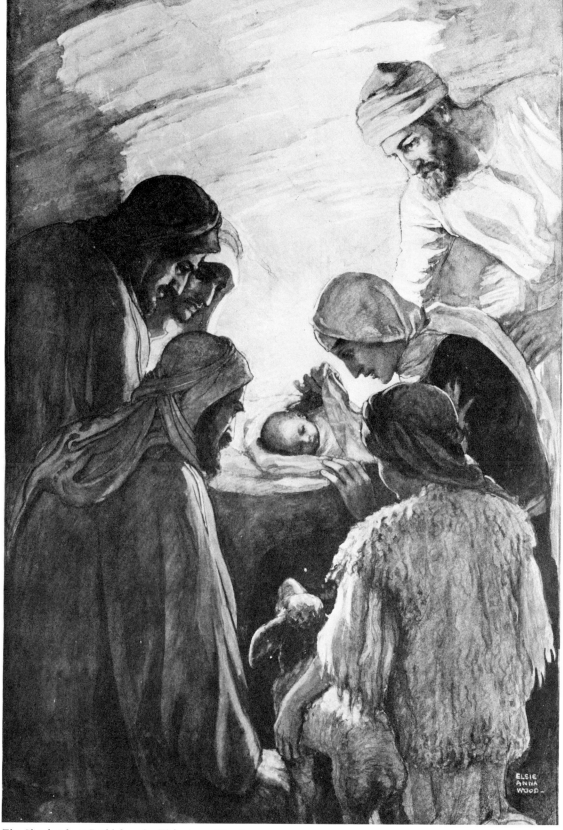

The Shepherds at Bethlehem by Elsie Anna Wood

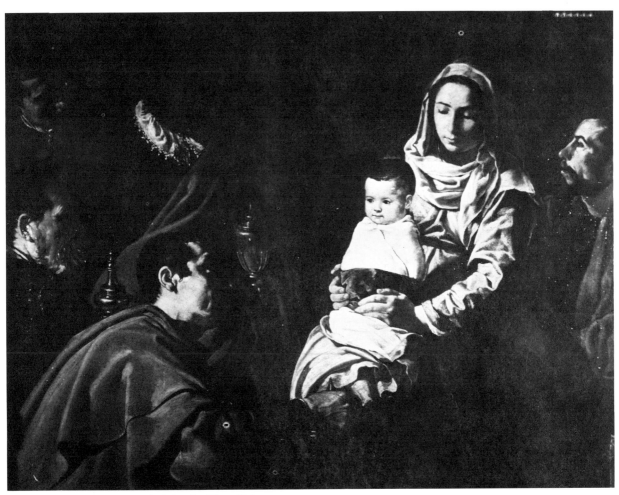

Adoration of the Magi by Diego Velazquez

What Would You Do?

You will have to find room to kneel close to the Christ Child in this picture, or you won't find out what you would do if you were the wise man who is about to give his gift.

The other two wise men do not know that there is a problem. They know that they have come a long way with their presents. They hoped to find a great king who would be delighted with their gifts and, perhaps, remember them and do them favors. They are waiting their turn, and wondering why the King is a baby and why He is not in a palace. When they come to kneel down before Him, they, too, will have a problem.

The one who is about to give his gift has stopped in the very middle of the act of giving. His hands are in an uncomfortable, halfway position. Look at his face. He has seen something that makes him stare in amazement.

He was just about to lift the top from his golden gift chest to display the treasure inside. But now things are all changed around. He thought he was the one giving the gift, and the Child was the one receiving.

Suddenly he knows this Child is offering him something—a gift to his heart, a gift of newness of life and wonder. It is too great for him to understand.

If the artist had been writing about this, instead of painting about it, he might have told us that Mary would have seen the man's problem and told him about the Child—the angel's promise to her, Joseph's dream, the shepherds and the heavenly host, and all the wonders of the Child which, even she, could not fully understand.

An artist cannot always fill in what a writer might say. So we are left with the wise man's moment of amazement, and we say to ourselves:

"What will he do? What would I do?"

Come Very Quietly into

Mary is praying. If you come into the picture you must not disturb her worship. If you do, the picture will be spoiled for you.

It looks as though Mary has decided, just at this moment, to kneel and pray. She had lifted the Baby from the manger, picking up a little of the straw with His soft blanket as she bent over and caught Him into a fold of her own blue mantle. Perhaps she intended to feed Him, or carry Him out into the sunshine. But at the moment, as it must often have happened to her, the wonder of *who He was* swept over her.

In one swift, gentle movement she laid Him down and knelt before Him.

Did she feel a special kind of stillness? Or was it like a silver chime of church bells? Did it make her want to pray?

The artist tells us what he imagines. He shows us that she might not have touched Him even with the tips of her fingers at that moment.

See how her hands are held.

Don't you think, "Holy! Holy! Holy!" are the words she has just spoken?

The Christ is our friend. We talk to Him like a friend and enjoy Him like a friend. Sometimes, though, does the wonder of Who He is make you feel still inside?

This Picture

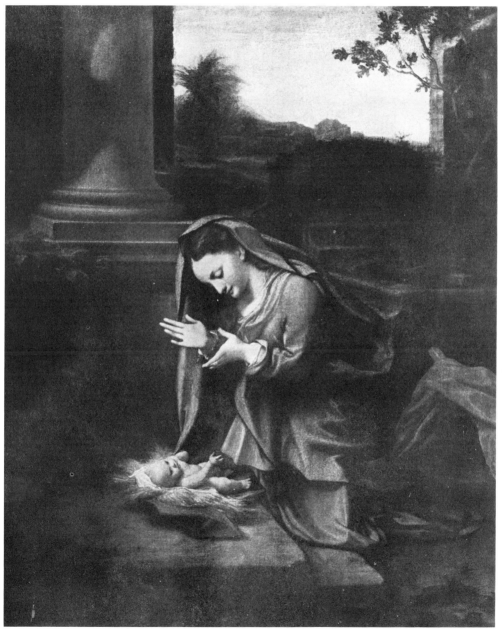

The Virgin Adoring the Christ Child by Allegri da Correggio

Finger-trace This Picture

There's a chair for you if you want to sit down—or is it a chair that is just showing at the bottom right-hand corner?

There's pencil and paper on the windowsill if you want to write down what you see—and a milk pitcher if you're thirsty. But don't move them just yet. They are part of the picture you are going to trace.

Actually, you should wait until you are angry, or disappointed, to get the most out of tracing this picture. Then, it has a "magic." Then, you will begin by looking out the window and seeing nothing, or nearly nothing. (We don't see well when we can only think about how we feel.) Your finger begins by tracing the lines of the roofs and the sides of the houses, around the door and the porch—straight lines, chilly but clear. By the time you run along the fence you are beginning to see better.

Now you are tracing the trees with your finger. It's like running or singing or dancing. Sometimes a twig or a branch cuts off short and you stop. It is as though music stopped suddenly. Maybe you wish it hadn't happened to the tree that way. Maybe it is like being angry or disappointed. But it doesn't spoil the painting, does it? And it is true about trees. And people?

Your mind takes your finger inside now, where people live. It is warmer inside. There are double windows against the cold. The lines of the window frame and sill go around and around. As your finger turns each corner you feel the magic. Something happens to you like the humming of happiness. You feel better.

You don't need to make a list. Leave the pencil where it is.

But the pitcher, . . . trace around its handle and its mouth. It is especially for you—look how it leans to you.

Maybe we could give this painting another name. I would call it, *Lines of God's Peace.*

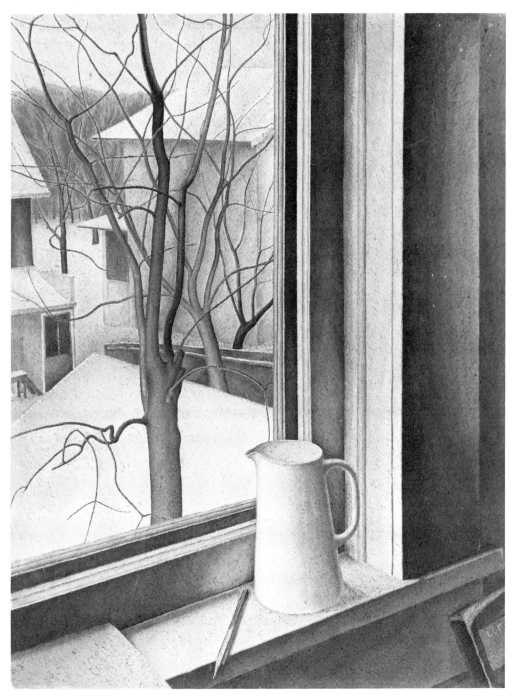

From an Upstairs Window, Winter by L. L. Fitzgerald

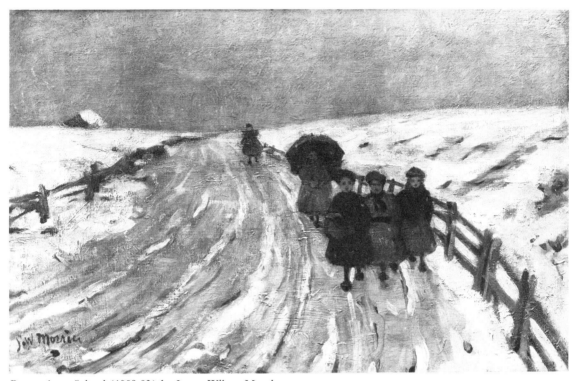

Return from School (1900-03) by James Wilson Morrice

Can You Always See the Umbrella?

Do you come home from school along a country road or a city street? It doesn't matter which, really. The feelings you can have are just the same.

In this picture you can feel the soft comfortableness of going home to a warm house that smells of cookies. The sky is a woolly grey blanket, shaking out great white flakes on your face and the road, and the fields are white—and waiting like the sheets of a turned-down bed.

This is the gentle scene James W. Morrice has painted for us.

Did you notice that you cannot see the school behind you or the houses ahead? And there are no adults here. It is a children's road. The three girls at the front of the picture seem to be happy on their way from school. They are together. They are friends. The walk home from school doesn't seem long at all.

But there are two other children on the way home, too. Do you know how it would feel to be one of them?

We can only guess, of course. But the one with the umbrella doesn't seem to belong. Maybe she has had a bad cold and her mother wouldn't let her go to school unless she promised to keep the wet snow off with that umbrella. There are other kinds of "umbrellas" that boys and girls carry. Nobody can see them, but they make it hard to get close to these boys and girls. These umbrellas are the things that are different about us. Sometimes it's the ideas and fears we carry around as part of us. Everyone has them. Some show them more than others.

The girl who is a little behind all the others is making a real effort to catch up. She may be calling to the others to wait for her. They don't seem to be paying any attention to her, do they? Why is she behind? Could she help it? We don't know. But we all know how it feels to be behind.

Where are you in this picture today? We change places on the road, don't we? If we think about it, we should know how each different place feels. If we always remember this, will it make a difference to someone else?

On the days when our umbrella is hard to put up with, or when we are very far behind, we know we are never really alone. Christ is always with us on the road from school.

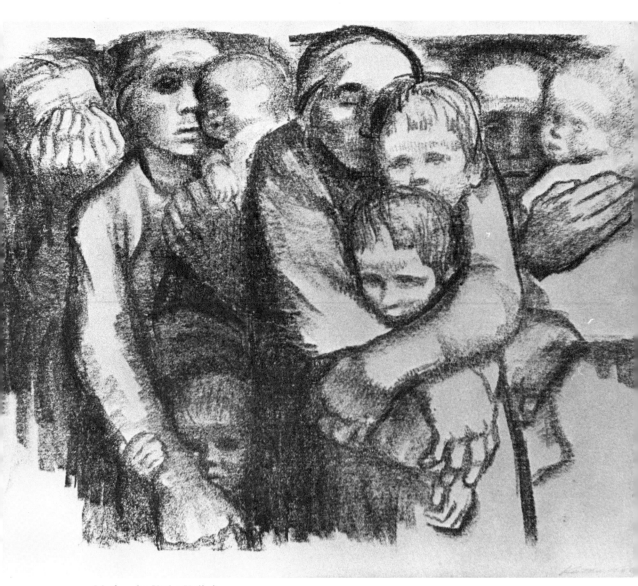

Mothers by Käthe Kollwitz

Where Are the Fathers?

War has taken the fathers away. The mothers are trying to be father and mother. It isn't easy. Look into their faces, and you will be able to guess some of their thoughts.

One mother's face is covered up by her hands. She doesn't want you to see her cry. She has no child. Why is she here with the other mothers?

A war makes mothers and fathers afraid like this. Afraid of what happens to their children—afraid because they love them so much and cannot be sure they will be able to keep them safe.

Now look at the children's faces. Which of these five children know that their mothers are afraid? Do any of them look as worried as the mothers? Why is it not quite so frightening for them?

Someone wanted to say how important parents are. They wanted to say it with all the emphasis imaginable. This made them say something that wasn't true. They went too far and spoiled it. This is what they said: "God could not be everywhere, so He made mothers."

You know what is wrong with that. It tells what isn't true about God. God *can* be everywhere. God *is* everywhere.

Now, if they had said, "Mothers and fathers can't be everywhere," it would have been true.

The mothers in the picture know this and they are afraid. Afraid they won't always be there when their children need them.

Who is always with boys and girls? Who is it that is never afraid and what is stronger than fear?

Are You Here?

This is a sculpture by Käthe Kollwitz that is formed like a plaque. She has called it, *Rest in the Peace of His Hands.*

In her picture called *Mothers,* she showed mothers who were worried because they might not be able to take care of their children during the war. They were afraid they might not always be with their children.

The sculpture you are looking at has something to say about this. It says:

WHO it is that never goes away,

WHO is never afraid,

WHO can be trusted, whether we are awake or asleep

 —in war and peace

 —at home in this world

 —or with Him in the home He plans for us when we leave this world.

Our church tells us this in words read from the Bible. Our ministers tell us in words they say from their pulpits.

The artist doesn't use words to tell us this, but she tells it well.

This is a look-and-feel picture. Look for the rest in the face carved in this sculpture. Imagine the feel of it with your fingers—around the mouth and nose and eyes—the smoothness of rest and trust.

Look for the love and care of God symbolized in His hands. One hand is for love, holding the one who is resting secure. The other is for protection. Can you tell what the right hand does?

The smaller hand above the hands of God, the hand of the one who is resting—what do you see and feel in it? It is not resting. It is holding on as though it said, "I never, never want to leave you."

Close your eyes and think of the warmth of His wonderful love and care around you. It is the most comfortable feeling in the world to rest in His care and to say, "I never, never want to leave you."

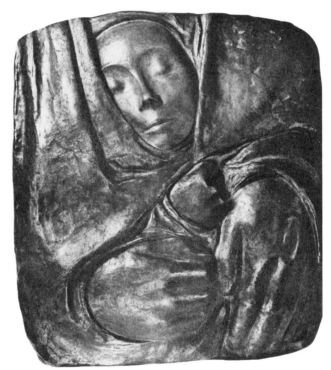

Rest in the Peace of His Hands by Käthe Kollwitz

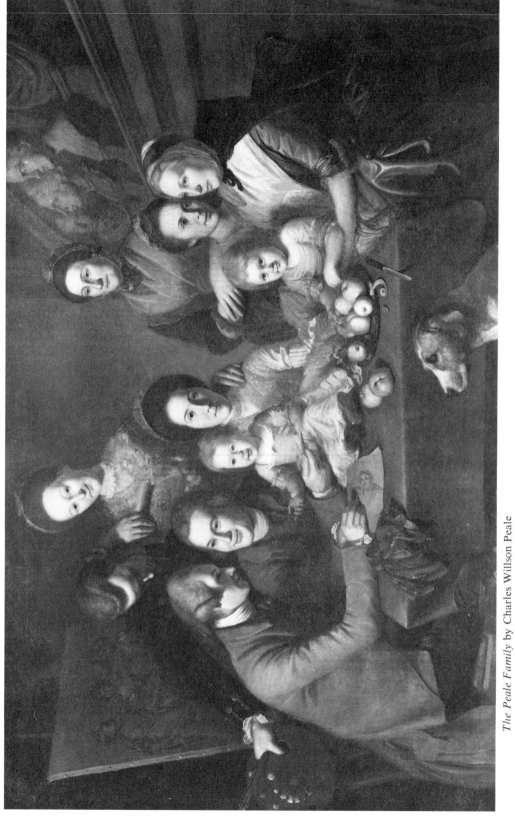

The Peale Family by Charles Willson Peale

Would You Like
to Be in This Picture?

This is a kind of "art party." Everyone is interested in drawing.

The artist who painted this family is standing beside his canvas with his palette in his hand. His brother is sketching their mother and her grandchild, seated at the other end of the table. Everyone is watching the one who is drawing or the ones who are being drawn, or they are thinking about being part of the larger picture which takes in everyone.

Look at their eyes, and you will know whether they are thinking about the little sketch or the whole family picture.

Charles Willson Peale was so interested in painting that he got his whole family involved. You can see that they were all used to this kind of art party and enjoyed it. Peale gave his own sons the names of two great artists Rembrandt and Raphael. Both boys grew up to be painters.

The children's nurse is part of this art party, too. She is standing with her hands clasped in front of her, just as aware of being in the picture as anyone else. The nurse and the grandmother look as though they remember what it used to be like when Charles and the others were growing up.

If you were making up a title for this picture, you might call it, *The Happy Family*. But the title wouldn't mean that this family never had a quarrel or never argued or disagreed.

Every one of them has a mind of his own.

A family is like a motor. It has many parts. Sometimes it sputters and develops serious noises. But we don't buy a motor for its noise. We buy it for its strength.

There is a great deal of family strength showing in this picture. Here is a list of the things that make up this strength. See if you can match them up with the faces around the table: encouragement, wisdom, loyalty, love, trust, approval, sharing, happiness.

Have You Ever Seen This

It is hard to describe, but most of us have a particular kind of feeling about "our" day.

We feel warm and excited and in the center of a circle somehow. It is being chosen for something special.

In this painting we almost step into a fairy tale. The artist loves his wife Bella as much as if she were a fairy princess. Her birthday gives him a chance to tell her all over again how glad he is to have her, how glad he is that she was born. How wonderful the world is just because of her, Bella.

He could have written her a poem or a birthday song, but nothing could have said it better than this picture called *Birthday*.

He tells her that she makes him so happy he walks on air and feels enchanted. Everything is brighter and more alive and colorful and exciting because she is Bella. And today is her birthday.

Look at Bella's face. He has made her feel the surprise of being special and chosen and loved. It is every bit as good as being in a fairy tale. It is better—because it is real!

Everyone in your family would like to feel like Bella on their birthday. Can you do anything about it?

Birthday Magic?

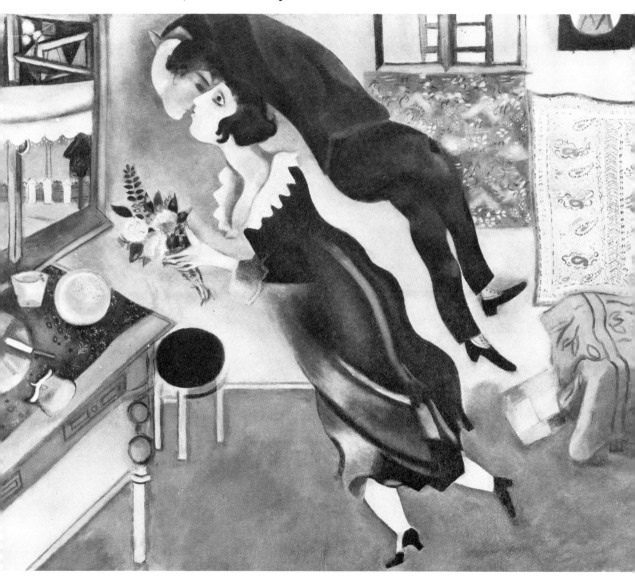

Birthday by Marc Chagall

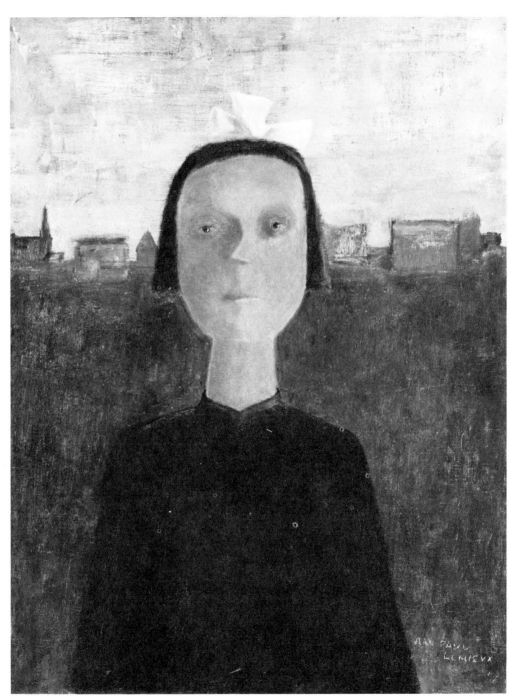

The Orphan by Jean-Paul Lemieux

What Has Happened?

Have you ever felt as this girl feels? The artist, Jean-Paul Lemieux, wanted you to understand her, so he painted how she felt, instead of how she looked.

He painted homes in the background; but she doesn't feel at home. Just now she doesn't feel anyone near her. Her face looks afraid. She hasn't done anything wrong, but she is afraid.

All of us have felt like this for an hour or so, or even longer. This is the feeling of being alone, very, very alone—not knowing quite why and not knowing what to do about it. The next day, things are different—everybody is friends again, and there is something exciting to do. We are on the team. We talk and laugh. Everybody is talking and laughing at once. Nobody notices the alone ones—not because anybody wants to hurt them, only because they are so quiet that nobody sees them go away. And there they are, alone again, like the girl in this picture.

The artist wants her to tell us how this feels when it goes on and on for days and weeks and even longer.

She is trying to be brave. He has made her mouth so it won't say out loud how it hurts to be alone. He has made her eyes hold back the tears.

She is so close up to you. Just for a minute, change places with her. Then it will be your eyes looking out and your aloneness behind the tight little mouth.

But it really isn't you. You are on the outside of this picture. No matter how alone you may feel, you are always on the outside, because there is always someone lonelier than you. They are looking at you. They are afraid—afraid you will not make friends.

It is so easy not to see the alone ones, even when they are right in front of you. They don't always look as they feel. You have to care enough to look twice.

Ask God, just now, to help you think about this at school and when you are playing games.

47

Have you ever been afraid? Most people would answer yes. Being afraid is sometimes a good thing. If people were never afraid, they would rush out on the highway without looking. They would go beyond their depth when they didn't know how to swim. They would do dangerous things and get into all kinds of trouble.

Sometimes, even when we are standing just where we belong, we are afraid. This is because we can see that we are in the middle of danger or trouble. If we are alone sometimes, we feel even more afraid.

Jesus the Christ knew how frightened you and I can be. He had something important to say about it. He wanted us to understand exactly what He will do about it. To illustrate this He talked about sheep and their shepherd. He, of course, is the Good Shepherd, and we are the sheep.

Some people think it is not a compliment to be compared to a sheep. That is only because they don't know much about sheep. They think sheep are silly animals without any mind of their own. This isn't true at all. Here are some facts about sheep:

A sheep farmer recently said that sheep are more intelligent than horses. It is true that they follow the sheep that acts as leader, but we should realize how wise they are to do this. They like company, and you can't keep people or sheep together without somebody leading, can you? The sheep also have a problem that may have something to do with their wanting to stay together. Their problem is their eyesight. They have enough eyesight to get their food and live happy and contented lives, but actually they cannot see much farther than halfway across a road. Many people keep their sheep fenced inside good pastures where they are safe. If they are to wander around the country, they must have a shepherd to look after them. It is part of the nature of sheep, so they say, to look up to something higher than themselves.

Check back now to see how well you and I fit into Jesus' illustration about sheep and shepherds. He really couldn't have found a better example. We, like sheep, are intelligent. We also like company and follow leaders. We cannot see what is going to happen beyond this very minute. This means that we need someone with us who can see the future, someone we can look up to.

Our Good Shepherd has said He will never leave us. It is most important to remember this when we are afraid. It means that whatever happens, the One who knows best is beside us.

You belong in this picture because you, too, have Christ with you.

You Belong in This Picture

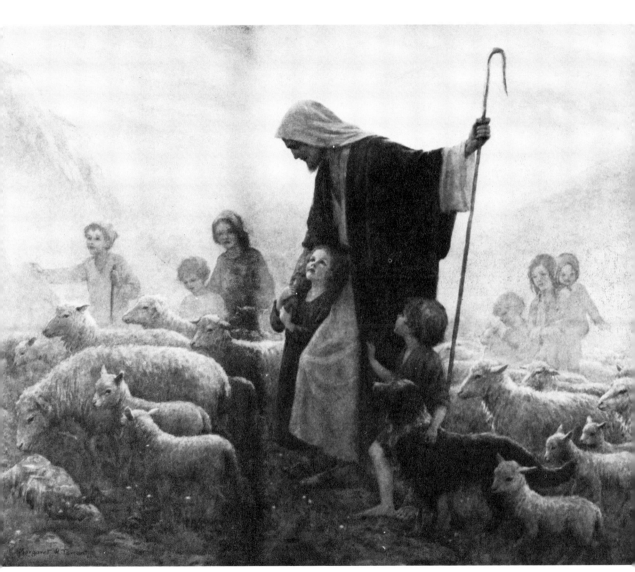

Loving Shepherd of Thy Sheep by Margaret Tarrant

Can You Find
the Answer in This Picture?

It looks like a riddle, doesn't it? The answer is in one of the corners. Can you find it?

In the very center is a church with most of its roof lifted off so that we can see what is going on inside. At the far end you can see the church organist, the choir, and the choir leader. At the front you can see the minister, and in between is the congregation. The clue to the answer is somewhere in the church. Have you found it?

Over where the dark clouds are, there is a war going on. Planes and parachute troops are in the air, and below are people who have been wounded.

To the right of the picture is a scene from one of the stories we know about Jesus.

Come back along the path toward the front of the picture, and you will see a funeral procession passing the church.

Now you are back in the church again. The clue is here. Have you found it yet?

It is the minister's finger. Draw a straight line from the tip of it in the direction it is pointing, and you will come to what happened in that story about Jesus (the one that tells about His calling His dead friend Lazarus to come back to life again). Lazarus is shown in this picture just as his family begins to realize that he is alive again. Do you see the touches of light around them, showing the great happiness that they are beginning to feel?

The riddle is in the dark parts of the picture where people are sad and hurt. They are asking the riddle's question, "Will this never be over? Will we never be happy again?"

The minister gives the answer. He is saying something like this: "Just as Jesus gave new life to Lazarus, He can give life everlasting to all of us. No matter what happens in the world, the power of the Christ never changes. He can change death into life."

Right at the top of the picture, in the very center is the cross with the sun shining on it. It stands for Christ and reminds us that once we have found the answer to this riddle, we should never forget it.

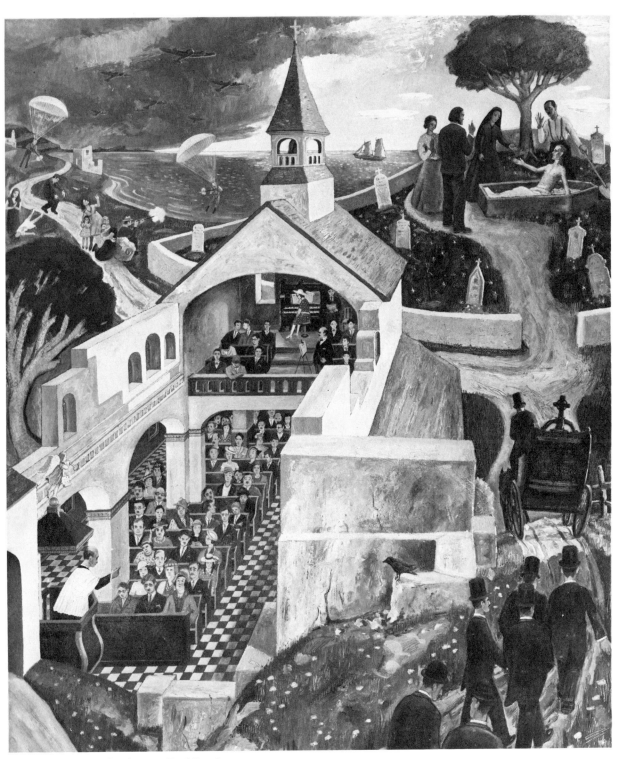

Lazarus (1941) by Jean-Paul Lemieux

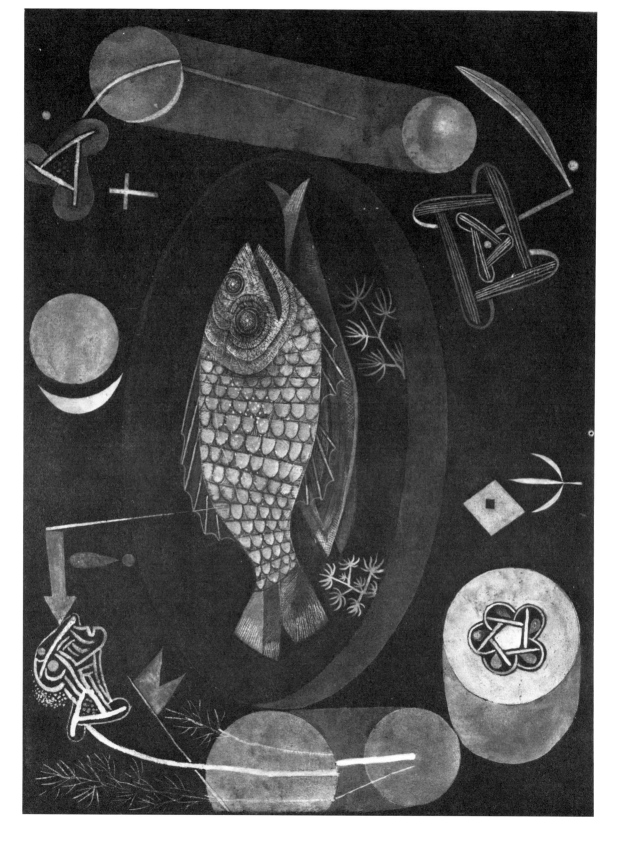

Is There
an Answer
to This Picture?

This picture seems to be a puzzle. The artist has given us a clue in his title, *Around the Fish,* and in some of the symbols he has drawn for us.

So many of the symbols are connected with church and the history of Christianity that we probably should look in the Bible for some clues.

We can see that the fish is the center of everything in the picture. And we know that the fish was the secret sign the first believers used to let one another know that they were Christians.

We can guess the artist is saying that Christ has always been in the center from the beginning of time.

John, who knew Jesus well and wrote about Him, used to call Him "the Word." Here is something John wrote. Change "the Word" to "Christ" and see what it tells you about Christ being at the beginning of the creation of the world:

"In the beginning was the Word, and the Word was with God, and the Word was God. The same was in the beginning with God. All things were made by him; and without him was not anything made that was made" (John 1:1-3).

Do you suppose the artist was talking about this in his picture? Do you think the shapes around the fish have something to do with creation?

To check it, turn to the first book of the Bible and see if some of the things mentioned are in the picture (Genesis 1:11-27). Look for these: plants, trees, fruit with its seeds, two great lights, a man.

This does not include everything around the fish, but there are some clues here.

And we should notice that everything is floating as though related to space or coming together in space.

The man is in some way related to the fish. The arrow and exclamation mark tell us this.

Did you pick out the Cross? It is placed clearly so that we can see that it was in the plan from the beginning.

No one can tell you all there is in this picture. It is a secret between you and the artist.

Around the Fish (1926) by Paul Klee

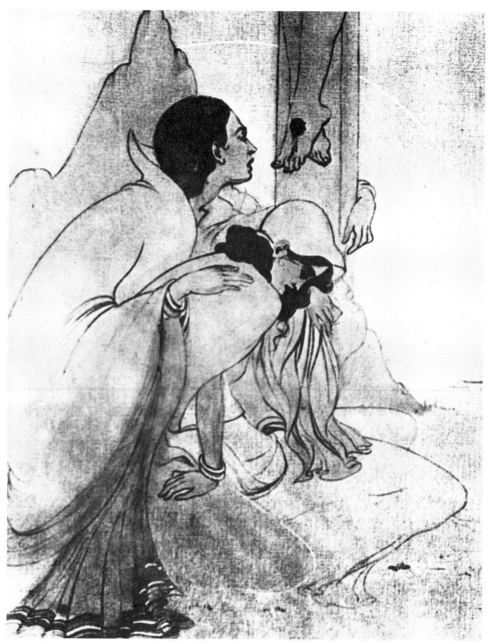

At the Foot of the Cross by Alfred D. Thomas

Have You Seen This Picture Before?

This picture is by an artist from India. He studied in Italy, and his pictures combine the delicacy and rhythm of Indian art with the special gifts for which painters in Italy are famous. This is what you could call an East-West picture.

Perhaps you haven't seen it before. In any case, it is a picture you will come back to as though it were new. This is because it almost insists that you come closer—close enough to be at the foot of the Cross. Every time we come close to the Cross in our thinking, we find it is not like repeating any other experience. There is always a feeling of *now*. We do not think about what year this happened or about what year it is now. Time doesn't count at the foot of the Cross, because what Jesus did was an eternal thing.

The artist says this in such simple lines. Did you notice the suggestion of the never-ending circle of eternity picking up the jagged outline of the Himalayan Mountains of India, which represent here and now?

The lines of the figures and their clothing speak to us like sad, sad music. They tell of the suffering of Jesus and the deep sorrow of the two who are with Him.

One of the women—the one whose head is bowed—is fainting from the pain of it. With one hand she tries to steady herself. The other hand is limp, but still touching the Cross.

The other woman's hands are holding the fainting woman. Have you found these hands? When you do, you will notice that while her hands hold the other woman, her eyes are on the feet of Jesus.

Usually, the whole figure of Jesus is shown in a painting about the Crucifixion. Only the feet are seen here. What thoughts come to you about this?

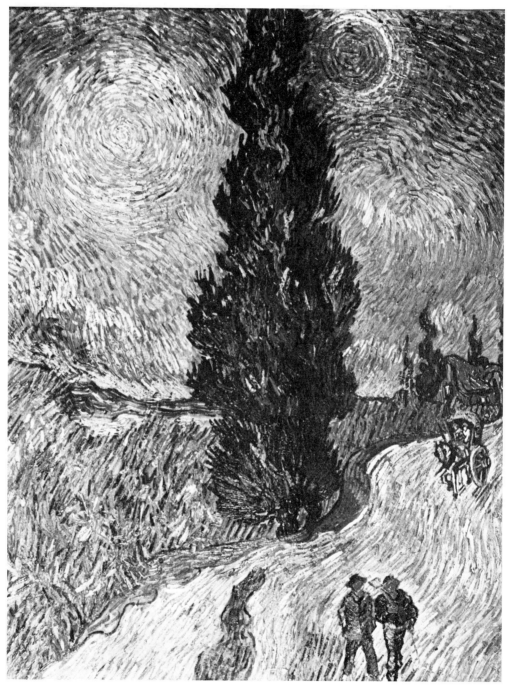

Road with Cypresses by Vincent Van Gogh

Is It an Easter Picture?

What belongs in an Easter painting? Angels, an empty tomb, the woman weeping? Certainly all these things remind us of the first Easter.

But these things are really the ending of a chapter, a chapter where a black and unimaginable thing happened—Jesus was crucified.

But Easter was His victory. He won it for all time, for all people, in all places.

The Maker and Master of life defeated the holding power of death. And all through the earth He shed abroad His own *aliveness*.

He said, "Look, I am *alive* forevermore," and, "Because I am *alive,* you shall *live* also."

This kind of life is for keeps. It goes on forever. That is the excitement of it.

How could a painter put that kind of excitement into a picture? *If* he could, it would never stay still on his canvas.

This picture certainly tells some of it. Look at the aliveness, the throbbing cosmic wonder of it!

What shall we call it? . . . *Life Forever, or Joy of Easter?*

Are We in the "Same Boat"?

This was not many days after the first Easter—the day when Jesus' friends were wild with happiness because He was alive again.

Yet, it was different. He came and went now unexpectedly. Doors and distance were no barrier to Him. He had beaten death and time and every problem they could think of.

All this was true. . . . And then they went fishing. Somehow we get the feeling that they forget that Jesus could have gone with them.

They spent the night fishing, but the fish just weren't there. In the first light of the morning they saw a man on the shore. He was signaling them to try fishing from the other side of the boat. And what a catch! Peter looked at the figure on the shore. With a shout he was in the water. He knew it was Jesus, and he couldn't wait for the boat to be beached.

Breakfast was ready, and Peter and the others were ready for it. What a wonderful time they had with Jesus. Everyone was in good humor. Just to be with Jesus was to have the Easter happiness all over again.

And then He asked Peter a question, "Do you love me?"

Peter answered for them all. "Of course, of course, I love you," he said.

Jesus had had to ask them if they were His friends.

Are we in the same boat as Peter? Does He have to ask us, too?

Couldn't we say to Him, right now, that we are His friends?

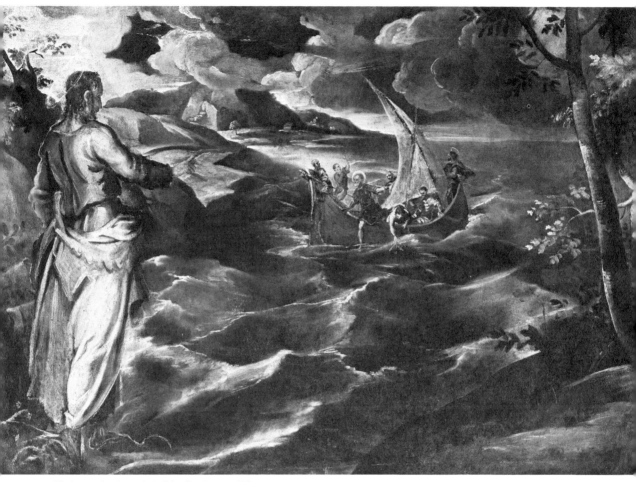

Christ at the Sea of Galilee by Jacopo Tintoretto

Watch This Picture Move

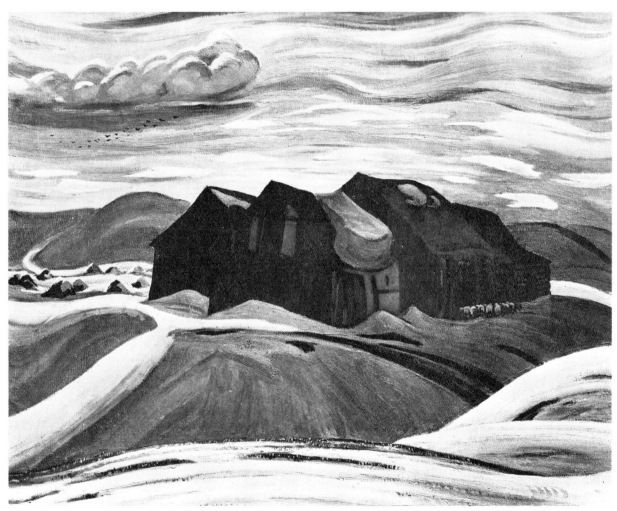

Barns (1926) by A. Y. Jackson

Are you in the picture? If you are, you are excited. If you are on the outside looking into the picture, it will seem to be moving—like the scenery we watch flying past the window of a moving car.

This picture by A. Y. Jackson is called *Barns*. Now barns are not very mobile. Neither are hills and snow. What is all the excitement about in this picture? What makes it so alive that it moves?

It is God at work—the most active, stirring, glorious kind of activity there is. When He is at work, all nature feels the throb of life. At this moment in the picture there is the first excitement and motion of spring— spring stirring in winter's clothes. The foreground of drifted snow gives us the motion of falls or rapids in a river. Even the hills in the distance are part of this flow. The sky moves faster still. Tumbling clouds on the left have formed to give us the impression of a locomotive's speed. A flight of birds is nonstop for the north. The sheep can't bear to stay indoors.

In the original the tired old barns are alight with the sun. They have been caught in the excitement and have taken on the appearance of a ship afloat on a billowy sea.

Watch for God at work in the forces of nature. Here you will see real excitement. You can feel inside you a kind of thrill as though He said, "Let there be light."

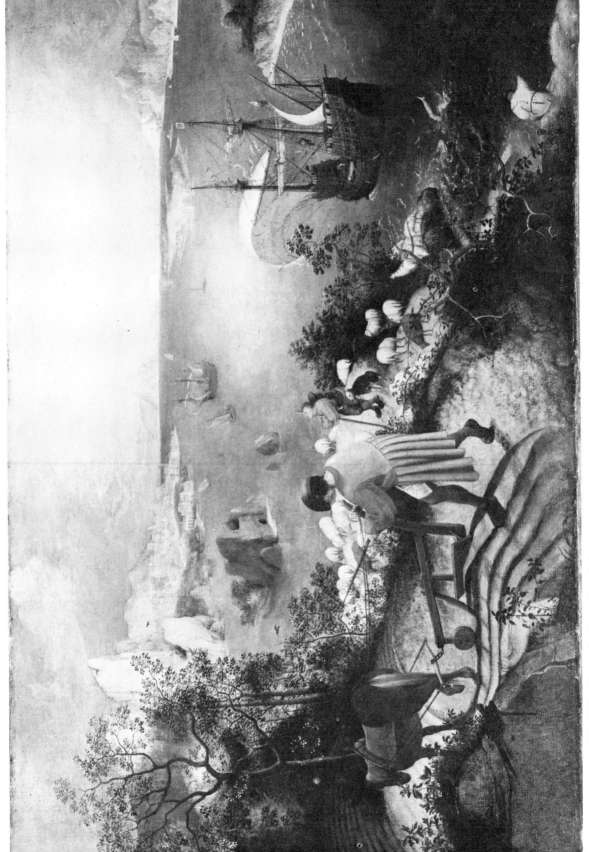

The Fall of Icarus by Peter Brueghel

Can You Find Icarus?

In Greek mythology Icarus and his father, Daedalus, wearing marvelous wings they had made of feathers and wax, escaped from the Island of Crete.

The wings carried them steadily upward to safety. Then Icarus, filled with a great sense of freedom and power, soared away from his father. Even the sun with its burning strength seemed as nothing to Icarus. He would be master of his fate, and no one would stop him.

Then it happened! The sun's heat melted the wax framework of Icarus' wings. He plummeted down, down faster even than he had soared.

Have you found him in the picture? He takes only a tiny space in the whole landscape-seascape. Only his legs appear above the green sea water.

Somewhere in the sky is a tiny speck, Daedalus flying on alone, heartbroken.

These two are the chief characters in the story, and yet they are almost invisible. Why do the earth and sea and sky fill the painting with their great scope and orderly beauty?

It is because the artist wants to tell you something. He thinks there is something vastly more important than the foolish mistake Icarus made. He thinks this important thing will give you a true sense of security.

Foolish arrogant people come and go. They do not change the nature of God or His plans.

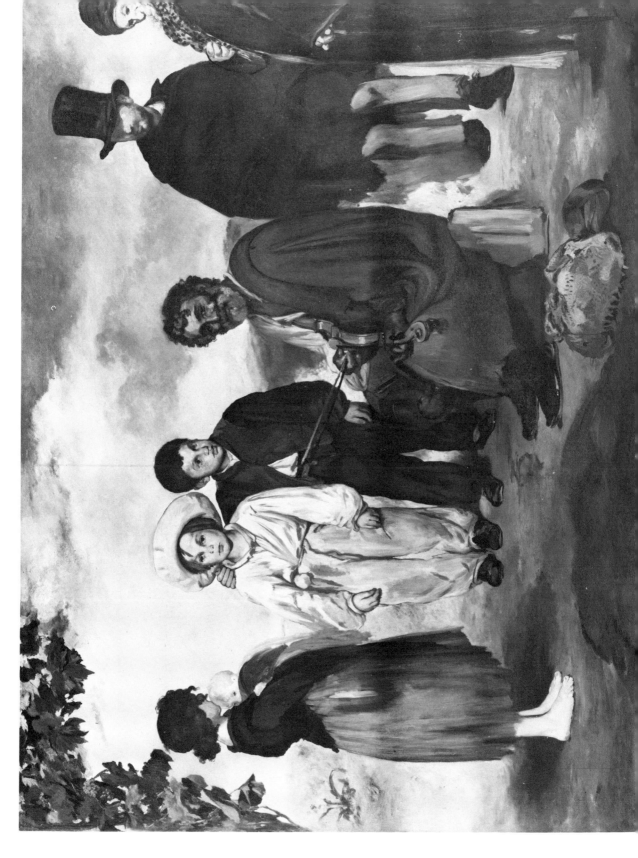

Don't You Remember Being in This Picture?

Perhaps you were wearing different clothes. Maybe it was in a different place with other people.

You couldn't be that wealthy old gentleman on the right-hand edge of the picture, nor the man in the very tall hat—not unless you have dressed up in somebody else's clothes. You couldn't be the baby. Are you the girl or one of the boys?

If you are there, nobody notices. Everyone has forgotten, for the moment, about other people—forgotten even about themselves.

The old traveling musician has just finished playing his music. He hasn't even looked in his hat for the coins people usually toss in when he plays.

Today something very special happened. His violin spoke so clearly, it called him and all the others out of themselves to the edge of pure beauty, to the place where hearts sing and make music in time and tune with God.

For a moment or two after the old musician stopped playing and the listening ears around him heard no more of his music, there was a stillness. Each one felt he was standing tiptoe on the edge of beauty, waiting . . . waiting a long, lovely minute before coming down to earth.

Look at them. Their faces show that they have lost themselves. They seem in that long minute to feel the nearness of God, the inventor of music and all beauty.

Have you been in this picture and felt this way? If you haven't, you'll know when it happens to you and, perhaps, you'll even remember this picture.

The Old Musician by Edouard Manet

Did You Ever Go to Sleep Like This?

Nobody knows who painted this picture, but everybody likes it. Art critics agree that it is, in its way, a masterpiece.

Nobody likes to see a baby crying or one that is hungry, cold, or untidy. Its unhappiness makes us unhappy.

Somebody once said that true happiness is seeing a child go singing down the road after we have shown him the way.

Another feeling of true happiness is seeing a comfortable baby. Have you ever noticed how people smile when they see one?

Now here is a really comfortable baby. See how the red chair fits him and hugs him a little. The pillow holds his head just right, so that it doesn't drop forward or backward. His shoulder nestles into it. It is a soft kind of pillow that fits—you can tell by the way it flops over the back of the chair. The baby's dress fits easily around his neck and his fat little arms. Nothing binds or rubs his soft, delicate skin. He has had a good lunch. His mother intends to tuck him into bed before long.

For a few minutes his hands were busy discovering his toes. But now, because he is so safe and so satisfied, he has dropped off to sleep right there in his red chair. Look at his feet, his hands, and his face. They all say, "I'm safe. I'm satisfied."

He is a comfortable baby. You can smile at him and feel inside you the feeling of his happiness and of God's care.

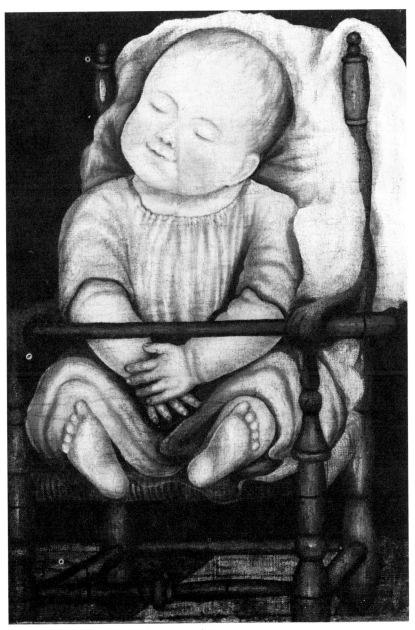

Baby in a Red Chair by an unknown artist

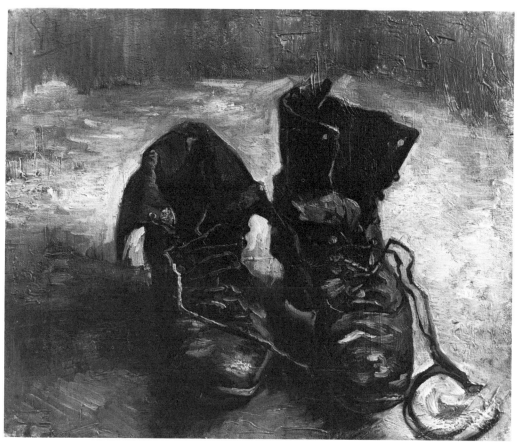

Old Shoes by Vincent Van Gogh

What Can You See in a Pair of Old Shoes?

Try this. Take your shoes off and set them in front of you and take a good look at them. What do they make you think about when you are not inside them? Aren't they more *you* than anything else you are wearing? They stand like you, don't they? They remind you, like a diary, of places you've been and things you've done.

The shoes in this picture. . . . We don't know who wore them, but we somehow know about him. They are work boots, and the only ones the man owns. You can guess that from the empty place where they stand and the careful way they were set down.

A boy who was looking at this picture said, "The man was very poor. His shoes weren't his own. He got his shoes out of some junk, and they were both for the same foot."

If that is true, they must have hurt all the time he wore them. His days were long days, and he must have felt like flinging his shoes across the room when he took them off.

Try, in your own imagination, to find out more about this man. You will be sorry for him and interested in him. And this is the very reason why the artist, van Gogh, painted those shoes—just to get you and me to care about people with tired feet inside old boots. People who work hard and have no shoes for play and no shoes for parties.

Can You Get in This Picture?

Perhaps you feel the giant trees will not let you into this picture. They do not look quite like real trees and this, too, may keep you out.

But this is a picture that is so real and so full of what matters to you that you were meant to get inside of it.

If you lived out on the west coast of the United States or Canada, these trees might seem quite true to life. The trees there are towering and majestic. If the artist had made their branches feathery and leafy, this effect would have been lost. She has given them the strength of solid wood. They are clothed in carved armor, which suggests strength. They tell of the closed, living vastness of great forests. They stand like overpowering strongholds of nature, ranged against man.

But right in the center of all this show of strength, man has answered back. There stands a little white church built by the hands of men out of the very timber of the trees. Not built to challenge nature, but built to praise God for his goodness and greatness.

Around the church is a cluster of graves. Christians who loved this church wanted to be buried close to it. Each grave has a cross to mark it like the church steeple. And each cross reminds us of what Christ's cross says about life. It talks about a kind of life that never ends, a kind that is quite different from life in the world of nature. The kind of life that Christ gave to us when He destroyed the power of death is a perfect kind of life. We feel that it is beginning just a little bit when we get inside this picture.

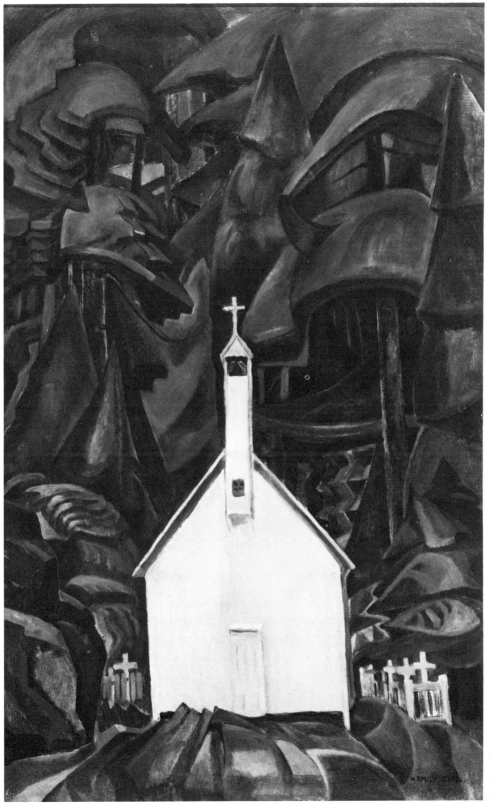

Indian Church (c. 1930) by Emily Carr

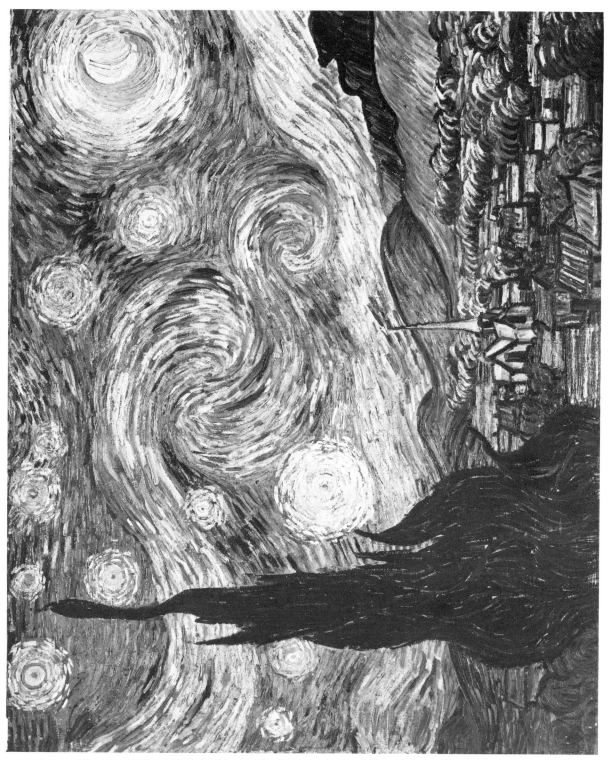

The Starry Night (1889) by Vincent Van Gogh

Try to See This Picture

In summer we move around. We take holidays in places a distance from home. What we see in the daytime may look very different from the roads or streets we are used to seeing at home. But when nighttime comes, there is not so much difference. The sky you will be looking at will be the very same one your friends at home will see.

The night sky melts the scenery of hills and valleys and water all together, so that the "oneness" of earth and sky and water is very real. This oneness comes from the fact that all three were made by the same Person and meant to be related to one another.

Sometimes it takes an artist to make this clear for us. Van Gogh, who painted this picture called *The Starry Night,* tells us very well. To show us that sky and earth have a oneness, he used the same kind of paintbrush strokes for both. He expresses aliveness and movement in the sky, hills, and trees so that it can scarcely be held inside the painting. It seems to say that God's creation is full to overflowing with life which goes on and on, 'round and 'round the calendar.

The dark tree that shoots up into the sky is *flaming* with life. In this painting the planets, whose movement is like a stately dance, and the stars, those distant suns, whose light burns and vibrates, are shown to us in a way our ordinary eyes do not see them. Van Gogh has done in a painting something like photographers do when they take pictures of flowers unfolding from bud to full bloom.

Keep looking into this picture until you see more and more of this. It may make you feel excited at first because of the great rush of movement, but afterward the oneness will be there for you to see. And after that you may feel a stillness inside of yourself. You may feel that God is waiting for you to speak.

Try really to *see* this picture and to look at the sky every starry night this summer.

"The heavens declare the glory of God; and the firmament sheweth his handiwork. Day unto day uttereth speech, and night unto night sheweth knowledge" (Psalm 19:1, 2).

Index of Essays, Artists, and Works

Titles of essays are printed in ordinary roman type, artists' names in CAPITALS, and the works of the artists in *italics*

Index of Topics and Scripture References

Easter

At the Foot of the Cross. "Greater love has no man than this, that a man lay down his life for his friends" (John 15:13). **55**

Christ at the Sea of Galilee. "He who has my commandments and keeps them, he it is who loves me; and he who loves me will be loved by my Father, and I will love him and will manifest myself to him" (John 14:21). **58**

Road with Cypresses. "I came that they may have life, and have it abundantly" (John 10:10b). **57**

Family

Birthday, The. "Love one another with brotherly affection" (Rom. 12:10). **44**

Peale Family, The. "Now there are varieties of gifts, but the same Spirit; and there are varieties of service, but the same Lord; and there are varieties of working, but it is the same God who inspires them all in every one" (I Cor. 12:4-6). **43**

Joy

Starry Night, The. "By the word of the Lord the heavens were made, and all their host by the breath of his mouth" (Ps. 33:6). **75**

Study in Movement. "The mountains and the hills before you shall break forth into singing, and all the trees of the field shall clap their hands" (Isa. 55:12). **13**

Life

Lazarus. "Because I live, you will live also" (John 14:19). **50**

Nature

Barns. "Let the heavens be glad, and let the earth rejoice, and let them say among the nations, 'The Lord reigns!' " (I Chron. 16:31). **61**

Frog. "And God saw everything that he had made, and behold, it was very good" (Gen. 1:31). **65**

Prayer

Angelus, The. "Therefore the Lord waits to be gracious to you; therefore he exalts himself to show mercy to you. For the Lord is a God of justice; blessed are all those who wait for him" (Isa. 30:18). **9**

Security

Fall of Icarus, The. "The counsel of the Lord stands for ever, the thoughts of his heart to all generations" (Ps. 33:11). **63**

Mothers. "As one whom his mother comforts, so I will comfort you" (Isa. 66:13). 39

Rest in the Peace of His Hands. "Cast all you anxieties on him, for he cares about you" (I Pet. 5:7). **40**

Return from School. "I will never fail you nor forsake you" (Heb. 13:5). **37**

Thanksgiving

Bountiful Board. "Thou crownest the year with thy bounty" (Ps. 65:11). **24**

Trouble

Reef and Rainbow. "For the moment all discipline seems painful rather than pleasant; later it yields the peaceful fruit of righteousness to those who have been trained by it" (Heb. 12:11). **22**